THE REMOVAL OF THE PARADOX OF THE POVERTY WITHIN THE ABUNDANCE
The Law of Zero Profit

By

Moe Messavussu
A.A.S, Kennedy King College, 2010
B.A., Chicago State University, 2014

THESIS

Submitted in partial fulfillment of the requirements
For the Degree of Master of Fine Arts in Independent Film
and Digital Imaging

Governors State University
University Park, IL 60484

2018

To my children
Sylvie, Emilie, Charbel and Joséphine

THE REMOVAL OF THE PARADOX OF THE
POVERTY
WITHIN THE ABUNDANCE
The Law of Zero Profit

ALL RIGHTS OF TRANSLATION AND REPRODUC-
TION
FOR ALL COUNTRIES RESERVED

ISBN: 9781087069845
Imprint: Independently published

TABLE OF CONTENTS

CHAPTER 1: INTRODUCTION..........................1
CHAPTER 2: Adam Smith and the classical political economy..........................3
CHAPTER 3: David Ricardo and the other trainers of the classic Economic School.............................. 6
CHAPTER 4: John Maynard Keynes and the Keynesianism..........................11
CHAPTER 5: The Neo-classic economic School..........................13
CHAPTER 6: Karl Marx and the Critic of the political economy..........................15
CHAPTER 7: The Law of Zero Profit..................17
CHAPTER 8: Conclusion..................................25
POSTSCRIPT: The Removal of the Paradox of the Poverty within the Abundance..................................26

LIST OF FIGURES

Figure 1. A sleeping homeless on the bus stop bench in front of PNC Bank, shot by Moe Messavussu, December 2017.
Figure 2. A homeless sleeping on the edge of a street. Unknown photographer.
Figure 3. A sleeping homeless person under a bridge. Unknown photographer.
Figure 4. A homeless begging for help in the street's pedestrian crossing. Unknown photographer.
Figure 5. A young homeless sleeping on the edge of a pedestrian walkway. Unknown photographer.
Figure 6. Homeless persons occupying a side of a pedestrian walkway under a bridge. Unknown photographer.
Figure 7. Homeless persons occupying a vacant space under a bridge. Unknown photographer.
Figure 8. A young homeless sleeping under coconut trees on the edge of a beach. Unknown photographer.
Figure 9. A young homeless sleeping on the edge of a pedestrian walkway. Unknown photographer.
Figure 10. A homeless man sitting on the edge of a pedestrian walkway. Unknown photographer.
Figure 11. A homeless man sleeping in a pedestrian walkway. Unknown photographer.
Figure 12. A homeless man sleeping on the edge of a pedestrian walkway. Unknown photographer.
Figure 13. A homeless family staying on the edge of a pedestrian walkway. Unknown photographer.
Figure14. A young homeless sleeping on the edge of a pedestrian walkway. Unknown photographer.
Figure15. A homeless man sleeping on the edge of a pedestrian walkway. Unknown photographer.

Figure 16. A homeless person with his dog sleeping on the edge of a pedestrian walkway. Unknown photographer.
Figure 17. A young homeless sleeping on the edge of a pedestrian walkway. Unknown photographer.
Figure 18. A homeless man with his dog sleeping on the edge of a pedestrian walkway. Unknown photographer.
Figure 19. A homeless woman occupying the edge of a pedestrian walkway. Unknown photographer.
Figure 20. Homeless persons occupying a space under a bridge. Unknown photographer.
Figure 21. Homeless persons occupying a space under a bridge. Unknown photographer.
Figure 22. Homeless persons occupying a space aside of a highway. Unknown photographer.
Figure 23. A home of a homeless. Unknown photographer.
Figure 24. A home of a couple homeless. Unknown photographer.
Figure 25. A homeless woman sleeping on the edge of a pedestrian walkway. Unknown photographer.
Figure 26. A homeless woman standing on the edge of a pedestrian walkway. Unknown photographer.
Figure 27. A homeless woman sleeping on the edge of a pedestrian walkway. Unknown photographer.
Figure 28. A homeless man sitting on the edge of a pedestrian walkway. Unknown photographer.
Figure 29. A homeless man with his dog sleeping on the edge of a pedestrian walkway. Unknown photographer.
Figure 30. Homeless persons sleeping on the edge of a pedestrian walkway. Unknown photographer.
Figure 31. Homes of Homeless persons under a bridge. Unknown photographer.

Figure 32. Homes of Homeless persons under a bridge. Unknown photographer.
Figure 33. Homes of Homeless persons aside of a bridge. Unknown photographer.
Figure 34. A homeless person sittinging on the edge of a pedestrian walkway. Unknown photographer.
Figure 35. A homeless man sittinging on the edge of a pedestrian walkway. Unknown photographer.
Figure 36. A young homeless steppinging on the edge of a pedestrian walkway. Unknown photographer.
Figure 37. A homeless man sleeping on the edge of a pedestrian walkway. Unknown photographer.
Figure 38. A couple of homeless persons sleeping on the edge of a pedestrian walkway. Unknown photographer.
Figure 39. A young homeless sitting on the edge of a pedestrian walkway. Unknown photographer.
Figure 40. A couple of homelesses sleeping on the edge of a pedestrian walkway. Unknown photographer.
Figure 41. A young homeless resting on the edge of a pedestrian walkway. Unknown photographer.
Figure 42. The despair of the poor. Shot by Moe Messavussu. November 2017.

ABSTRACT

The problem of the homeless summaries in perfection the paradox of the extreme poverty within the material abundance that confirms the high state of industrial development of the United States of America. But this state of shocking poverty must be purely and simply curbed in order to celebrate the glorious human civilization.

I believe that the implementation of all reforms recommended by the "Law of Zero Profit", worth knowing the progressive institution of the free health insurance for all American citizens and assimilated-citizens, the institutionalization little by little of the perpetual unemployment insurance, and the gradual abolition of the work degrading the human being, will come at the end of the present distress of the American workers and will open the way for the realization of the terrestrial paradise dreamed by every human being for every human being.

KEY WORDS

Profit: According to the majority of the economists, the remuneration of the work (salary) is lower than the value, which it allows to produce. Thus, the capitalist or the owner of the capital appropriates a part of work. Called PROFIT

CHAPTER 1: INTRODUCTION

" From the time of Adam Smith generally considered as the father of the political economy, States are moved by a totally unpublished concept regarding national wealth, namely that the latter ensued from the work of their fellow countrymen and not from the gold. Indeed in the 18th century, the absolutists Nations-States were moved by the will to appropriate the world reserves of precious metals and to increase their own wealth." It is the raison why we can assert that all the American workers produce the American national wealth. But where the problem lies, is that has to make the American government when a part of the aforementioned American workers comes to lose their work and thus any livelihood? Does the American government have the right to let the aforementioned American workers become homeless persons? Either does it have to take necessary measures to create a cash register of perpetual unemployment-allowance to guarantee a minimum living wage for the aforementioned workers? (Messavussu, Moe 2012)

We define the "Law of Zero profit", given as a pure intellectual creation of the author of the present master's capstone thesis in fine arts at governors State University, the absolutely peaceful way to solve the problem of the incredible poverty within the material abundance in the most advanced modern industrialized societies in the world, namely the United States of America. To study the "Law of Zero Profit" from a scientific point of view, we take as space of study the city of Chicago. The choice of the aforementioned

locality as space of study, is purely fortuitous because the author of the present thesis lives in Chicago since the year 2002, is naturalized American but has no financial means to go to make its scientific and artistic work in a locality other than its residential city for soon sixteen years. The city of Chicago presents besides these enumerated advantages: In the first place, the industrialization accomplished in this known mentioned city presents the latter as a perfect model of industrialized space. Secondly, the population of Chicago represents a perfect model of cosmopolitan population and consequently, a perfect representation of the global American population. Thirdly, we can without errors generalize the results obtained here in Chicago to the entire U.S.A.

In the first part of our study, we are going to examine in depth the doctrine of Adam Smith regarding political economy, and the various improvements brought to the aforementioned theory in time to today, followed by its fundamental criticisms of which that of Karl Marx. In a second part of our presentation, we are going to examine the Law of Zero Profit followed by the unconscious application of the aforementioned law in various countries in the world, particularly in USA under the administration of Barack Obama that tried to institutionalize a health insurance accessible to everyone. In a third part of our study, which we assimilate to our conclusion, we shall use to demonstrate the nonsense of a governance of state, which tends to despise and throw to stinging nettles the aforementioned providential law for us.

CHAPTER 2: Adam Smith and the classical political economy

Adam Smith's book An Inquiry into the Nature and Causes of the Wealth of Nations" is generally admitted as the first modern treaty of political economy. This classic work establishes a pragmatic and coherent stage in the history of the economy. But before going farther, who is Adam Smith? Adam Smith was born on June 5th, 1723 at Kirkcaldy, in the Scotland. His father was a jurist. Francis Hutcheson, whose education is inspired at the time by the theories of John Locke and David Hume, introduces Smith to the moral philosophy. Having studied and have taught in Oxford and in Glasgow, Smith is appointed professor of logic to the university of Glasgow in 1751, then a professor of moral philosophy on the year later. During this period, he is in narrow contact with David Hume, whose ethical and economic theses influence him significantly. In 1763, he leaves Glasgow to begin an academic journey of two years, which leads him in France and in Switzerland, as a private guardian of a young duke. It is of these meetings with the French physiocrats Turgot and Quesnay that Smith develops the theme of his key work "An Inquiry into the Nature and Causes of the Wealth of Nations", that he can finish and publish only in 1776. In 1779, Smith is named police captain to customs in Edinburgh, where he lives until he dies, on July 17th, 1790. For Adam Smith, "the political economy, considered as a branch of the science of the statesman suggests supplying

an income abounding to the people and to the sovereign (Smith, Adam 1776). Very early the doctrine of "let make" which requires the free circulation of the goods and the people, expresses itself, the free individual initiative. Smith is then going to theorize about the conditions of the regulation by the market of the rising capitalism. From then on Smith asks himself the question: how to lead the nation to the highest level of wealth? Because the latter is defined as the annual production obtained thanks to the work, the enrichment of the nation rests on the increase of the amount of work and the improvement of its productivity. The analysis of Smith is dedicated in the conditions of improvement of the productivity of the work: these lean on the expansion of the walking exchange which makes possible the division of labor, the specialization of the tasks; so, increases the productive power of the work."

According to Adam Smith, before him, the wealth was essentially defined by two manners: For the mercantilists the wealth is defined by the ownership of metals and precious stones, because it is them which allow to finance the wars, it is them which have a sustainable value in the time and recognized everywhere. It is an essential princely wealth. For the physiocrats, the agricultural production is the only source of wealth, other activities being dedicated only to the transformation of this first wealth (Smith, Adam 1776). Then came Adam Smith for whom the wealth of the nations is the set of the products, which live up the life of the quite whole nation, that is all the classes of the society and their consumptions. The gold and the currency do not thus, establish any more the wealth, since they have in themselves no other utility that that

of the intermediary of the exchange. Most of the economists consider Adam Smith as "the father of the political economy", consequently the "father of the classic school". "For the classic school if there is one period of crisis, salaries, as well as prices, adapt themselves to the fluctuations in the offer and demand of economic products. The market absorbs these shocks and thus the unemployment is not important as it, it is a variable of adjustment (Smith, Adam 1776).

CHAPTER 3: David Ricardo and the other trainers of the Classic Economic School

The other figures of the classic school, namely, Ricardo David, Mill James Stuart, Malthus Thomas Robert, and Say John-Baptist systematized Adam Smith's theory, which became economic orthodoxy in the period ca 1815 – 1848. "The main axes of the political economy are so given as followed: The law of the automatic regulating invisible hand of the economy of Adam Smith, the law of the population of Thomas Robert Malthus, the theory of the diminishing returns of David Ricardo, the theory of the value work of Ricardo, the law of John-Baptist Say, which in its strong version leads to the principles of the money which cannot create activity, the theory of the comparative advantages, completed by John Stuart Mill who introduces the mutual demand".

For Smith, the selfish motive which brings every individual to improve his economic situation, thus engenders on the national level, beneficial effects by realizing the general interest as if the individuals were led without their knowledge by an invisible hand, a real auto regulating mechanism of the market which allows, thanks to the competition, an optimal use of the productive resources. In this respect, it is advisable not to bring in the State at the economic level, in order to not disrupt this spontaneous natural order based on the personal interest of every individual (Smith, Adam 1776).

In his book "An Essay on the Principles of

Population", the major concern of Malthus remains the problematic increase of the population. For him, the birth rate is such as the number of human beings tends to progress in a faster way than the quantity of food. This rule, valid for all human beings, had to incite to a voluntary limitation of the births, mainly by the backward movement of the age in the marriage and the sexual abstinence. Failing that, it is the insufficiency of food that will eliminate the human beings in excess (Malthus, Thomas Robert 1798). The said "Malthusian" politics were however been organized in certain countries as India and China, with the aim of mastering the population growth. The concept of the diminishing returns is applied to the agriculture in the book of Ricardo, David Principles of Political Economy and Taxation. According to this author, the more lands are exploited to face the increase of the population, the less they will be fertile and the yields will decrease. The exploitation of the resources is thus profitable for a small number of people but when the population increases and requires the exploitation of the other resources, these are less productive. This theory joins that of Thomas Robert Malthus, which supports that the increase of the population engenders the reduction of the available resources. "An example of diminishing returns is the exploitation of the deposits of the oil. The aforementioned exploitation decreases indeed because the operating costs were low when the deposits were close to the surface of the ground. But the more the resources in oil diminish as a result of the high demand, the more operating costs increase and are not thus more profitable". According to Ricardo, "the population growth leads to the reduction of the resources and is against the pro-

ductivity. It is thus essential to favor the technical progress, which allows to increase the efficiencies according to the demands, but also to specialize in an activity sector where we are the most productive."The Ricardo's second contribution to the classic School of political economy is the value-work. David Ricardo joins the theory of the value of Adam Smith by accepting the idea that there are two valuable types: the use value and the exchange value. But their reasoning differs as for the establishment of the exchange value of the good produced. For Ricardo, any goods are produced by the combination of direct work (that of the employees) and of indirect work (contained in the installations, the machines, etc.). Thus the exchange value of any good is the amount of work, which is incorporated into it (Ricardo David, 1817).

It is necessary to distinguish at Jean Baptist Say three proposals: "the first one is that the currency is economically neutral, that is it is a good, which cannot be looked for itself but only with the aim of buying other properties. The second is the postulate that the offer creates its proper demand. Each of us cannot buy the products of other than with his/her own products, because the value, which we can buy, is equal to the value, which we can produce, the men will buy especially as they will produce more. If certain goods are not sold, it is because others do not occur. It is the alone production, which opens outlets to products. Thus the level of the economic activity on the offer of products, which must be freely proposed to the consumers, and the third idea of Say is that the production creates the incomes. Any act of production is at the same time a distribution of incomes and increases the purchasing power of its author" (Say Jean Baptiste 1972 Chapters 15,16).

As for the theory of the comparative advantages, completed by John Stuart Mill who introduces the mutual demand, the problem is expressed in those terms. "The cooperation and specialization of two countries in the production where they have a comparative advantage increase the world wealth, but how this surplus of wealth will be shared? We can answer this question by wondering about the relative price of the products, that is about the number of ,and symmetrically". John Stuart Mill solves the question in his Principles of Political economy in 1848. He shows there that the determination of the international price of products answers the principles of the offer and the demand. Indeed, "for every possible relative price, the first country will wish to export a certain quantity of the good A and import a certain quantity of the good B. The second country will adopt a symmetric attitude by exporting the good B and by importing the good A. Yet, it seems improbable that the offered wanted quantities are similar. In fact, it should not, in principle, exist that a relative price for which the supply and the demand become equal, it is then the relative price noticed and determined by the market. This price also determines the exchanged quantities". John Stuart Mill so made of the theory of the comparative advantage a central element of the classic theory. He wrote: "To make the import of a product more advantageous than its production, it is not necessary that the foreign country is capable of producing it with less work and capital than us. We could even have an advantage in its production: but if we arrange such favorable circumstances as we already have a bigger advantage in the production of another product which is asked by the foreign country, we could be able of obtaining a

more important yield on our work and on our capital by using them not on the production of the article for which our advantage is lesser, but by dedicating them completely to the production of the one for which our advantage is biggest and by offering it to the foreign country in exchange for the other one. It is not a difference in absolute costs of production, which determines the exchange, but the difference in the relative costs". (Mill, John Stuart. 1848).

CHAPTER 4: John Maynard Keynes and the Keynesianism

The fundamental criticism of the classical theory comes from Keynes John Maynard. For Keynes, "an economy which is alive is an economy which consumes. The growth follows a sinuous way. Indeed there are the periods of expansion where the growth is present, the unemployment is then weak and the individuals can consume and take advantage of some fruit of their labor. But there are also periods of retraction of the economy, which cause reduction in the consumption, and thus a massive explosion of the unemployment follows. This period of cycle of growth and not growth is called the cycle of the business." For Keynes, "the global economic demand is the founding element of an economic cycle. Indeed, in times of crisis, the global demand lowers, what causes a slowing down of the general economy, and thus increases this period of crisis". "Keynes develops the idea according to which the demand aggregated must be directed to invert the demand qualified of the crisis and at the same time cleans up the instability of the capitalism. And this role of supports in the economy returns to the State which guarantees the economic health of the country". In summary, "Keynesianism is organized around six axes, namely, in the first place, the aggregated demand does not follow particular rule, secondly, the reduction in the consumption has mainly an impact on the production and

on the unemployment, thirdly, the prices and the salaries react only slowly to the general variations of the offer and the demand, fourthly, there is no perfect level of unemployment because it is too dependent on the economic situation, fifthly, the application of politics of stabilization can be necessary, and sixthly, in general way it is better to support the employment rather than to fight against the inflation (Keynes, John Maynard, 1936).

CHAPTER 5: The Neo-classic economic School

In the efforts to restore at all costs the capitalism after its heavy past crises, came the neo-classical school, and then recently the Austrian school. "Milton Friedman inaugurated an economic thought of liberal inspiration of which prescriptions oppose frontally that of Keynesianism. In answer to the function of Keynesian consumption, he developed the theory of the permanent income. In its simplest shape, the theory expresses that choices made by the consumers are dictated not by their current effective income, but by their estimation of income with long-term, which integrates the past, present income and to come one. The difference between the permanent income and the current income is called passing income. At the same time Friedman introduces in economy the notion of permanent income and consumption". But, for the Neo-classical School, the greatest representative is Paul Samuelson. For him, "the State has to intervene in the economy the time when the economy recuperates. For them, on the short term, markets do not always manage to stabilize because of the imperfections of the economic systems as also stiff salaries or the influence, which have monopolies on the competition. In the case, the Governments have to spend more to stabilize the economy and make leave the growth. When the growth returned, markets regulate by them the same and the invisible hand of the market works again marvelously." "The neo-classic synthesis thus comes in friendly with Keynes on

the short term. They both find that an intervention of the State is necessary in time of crisis. However, their opinions differ on the long term. For the neoclassic, the markets have to be free and find themselves their points of balance in normal period.

As for the Austrian school of which the father is Friedrich Von Hayek, "the market is the meeting of the individual preferences. Only the private individuals can fix the value of the economic goods and only the market can coordinate the preferences of every individual. For the Austrian school, the socialism removes the rational and subjective calculation that every individual made by the value of the economic good and in it, is lower than the liberalism.
Indeed, only the individuals are capable of knowing the costs and the profits of the economic goods because they are subjective. It is thus necessary to introduce the diversity of the notices of the consumers and to coordinate them in the economic sphere to run it. The prices play a then considerable role because they are the mirrors of the economy. For the Austrian school, in the socialism, the State sets the prices but as it knows only a part of the preferences of the consumers and specificities of markets it does not thus succeed and biases the market". This current of thought remained marginal until 1980 when Ronald Reagan and Margaret Thatcher are inspired by it for their politics. They were wild towards the interventionism of the State and advocated an aggravated liberalism. This ultra liberalism can bring to wonder whether, to claim a society can work correctly only without any decision-making of the State, is not a little extreme?" But the absolute condemnation of the capitalism came from Karl Heinrich Marx.

CHAPTER 6: Karl Marx and the Critic of the political economy

For Marx, the exploitation is present because of the capital-intensive profit, which imposes the profit. Marx, to explain the market, deduces that every good had two final values. The first one is the use value, which corresponds to the value of utility of the product, that is the use which we make of this good. The second is the exchange value, which corresponds to the monetary value of the good. Marx applies this comparison to the work because, according to him, the work is an element of the growth of the capitalism. The use value of the worker is the capacity to produce the goods, and its value of exchange is the salary, which he/she receives in exchange for this work. But, this use value of the worker comes to be added to the equipments of the company to produce the goods, which have then a cost upper to the monetary value of the work. Of this imbalance created a surplus which Marx calls the exploitation and which the employer keeps as profit (Marx, Karl 1867). The accumulation of the profit allows strengthening the capitalism. Even before inventing the economic Marxism, Karl Marx denounced and analyzed the origins of the capitalism. His first works are dedicated to the origins of the capitalism, to the aberration of the concentration of the wealth in a small number of hands. Marx evoked that this fast rise of the capitalism could grow to contradictions within the market and thus brings to a takeover of the means of production by the workers

who can then set up a communist economy. The communism comes from the idea of the class struggle advanced in the first one by Karl Marx. The class struggle highlights that a society is not homogeneous, it is subdivided into classes and its individuals have divergent aspirations. Karl Marx so shows that the class struggle is on the base of the history of our world and is present since the settlement of the people. Of this ideology, Karl Marx reveals a new social class: the proletariat, the social class, which has for only wealth its working strength. Karl Marx considers while this class has interest fundamentally in opposition with those of the bourgeoisie and while being the most numerous class it is capable of transforming the society to make it more egalitarian for all. If the Marxism defends the working class so cruelly, it is to fight against the alienation in the work. This notion developed by Karl Marx is the fact that in a capitalist system the work is not more than at he simple good. The work being for the price of the time of life for the benefit of the capitalism." "On this matter Karl Marx says the following: A man who arranges no leisure, among which the quite whole life, except the simple purely physical interruptions for the sleep, the meals, etc., is monopolized by his work for the capitalist, is less than a beast of burden. He is a simple machine to produce the wealth for others, crushed physically and dulled intellectually. And nevertheless, all the modern history shows that the capital, if we do not put it obstacle, works without respect nor pity to lower all the working class at this level of extreme degradation." (Marx, Karl 1859)

CHAPTER 7: The Law of Zero Profit

As for ma position in front of the workers, what is said is said: We have to save the capitalism or the free-entrepreneurship by promoting all the social-reforms recommended by the "Law of Zero Profit", worth knowing, the progressive institutionalization of the free Health Insurance for all American citizens and assimilated-citizens, the institutionalization little by little of the perpetual unemployment insurance, and the gradual abolition of the work degrading the human being. The main idea and the brief development of the "Law of Zero Profit" are afterward given by the series of hypothetical-deductible reasoning's, which follow. Indeed having studied all my documentary photos shot by myself or by other photographers (See fig.1 to fig.18), on the homeless persons living in Chicago and in the rest of the United States of America, I make three main arguments:
First, let us take the affordable health insurance for the American citizens and assimilated Americans. Because the current American presidency cannot repeal "Obama Care", let's consider the next stage of the providential enforcement of the "Law of Zero Profit" here in USA. Let's admit that the next stage of the American medical reform is the youth's coverage. Because it is not the point to waste the money of the American taxpayers, but to dedicate the human civilization [which considers that the death of the human being is a fate gladly changeable by God the Almighty in to the eternal youth and life], let us understand definitively that the affordable health insurance for all

citizens and assimilated-citizens begun by the American Administration under Barack Obama, inevitably has to continue with the coverage of the entire youth as next stage. No left to their own devices or half-witted young man or girl under parental control, but deprived by ways to meet their medical and pharmaceutical needs, can and must be abandoned to themselves by the American society, this in accordance with the row of the nation the most evolved in the world which is collectively awarded to the United States of America. That those who believe that the hope to see finally all the deprived and left - for account of the American society bloom thanks to the appropriate government's actions, is an empty hope because of the monumental leak of the American Capital towards the Foreigner and the increased unemployment on the national territory which follows itself, conceive from now on that it returns to the whole American population to continue to support the political action inspired by the "Law of Zero Profit". The famous affordable care committed here in the U.S.A. by the former American President Barack Obama's Administration, thus establishes the beginning of the application of the "Law of Zero Profit". I farther go away to consider the purely and simply free health insurance.
In one hand, let us consider the death of the human being decided by the society in which he/she lives. Let us admit that the death of the human being occurred as a result of the disease due to chronic lack of money to get itself necessary care for the survival, falls absolutely under the responsibility of the aforementioned society which refused the free care for the aforementioned human being. Let us admit that the

institution of the free health insurance for all the citizens and assimilated-citizens comes under the required fundamental measures so that a human society can be honored as having reached a great level of the building of the "absolute human happiness'. Let us admit that the free health insurance for every citizen and assimilated-citizen is a social political arrangement characterizing the real development of any modern and deserving State-Nation. In other hands, Let' s consider the division of the society in rich and poor. Let us admit that the wealth and the poverty are well and truly both faces of the human social condition, which wants that the rich can, in the day of tomorrow, becoming poor and vice versa. Let us admit that the natural factors, which produce the wealth of the human being on the economic and financial point of view, exist independently of those, which engender the poverty of this one. Let us admit that the human being, who arises from rich parents, has naturally all the chances of rich future too by inheritance. Let us admit that the human being, who arises from poor parents, has naturally all the chances to become poor too by inheritance. Let us admit that the intelligent or civilizing social measures which aim at giving the same chances to the child been born in a rich family and that been born in a poor family to become simply human beings happy to live or provided with all the economic and financial means that must assure them a pleasant and useful existence, and for the society in return, is greeted by God and considered objective and well-based. Let us admit that the set of the aforementioned intelligent social measures that must assure, if the nature allows it, a future also pleasant and useful existence for the

child been born in the poverty and that born in the wealth, is summarized by the free school and university instruction, and among others the free health insurance. It results from these the following reasoning: In the first place, the right for the free care which demands a child arisen from poor and incapable parents economically and financially unable to assume the health of their offspring, even their own health, falls absolutely to god the Almighty which delegates the aforementioned power to maintain the population of the concerned country in state of good health, through the Government elected democratically. In the second place, the society which breaks the obligation to assure the free access of health care to all citizens and assimilated-citizens, becomes consequently guilty of a crime against the humanity in the eyes of God and loses its grace of blessed or prosperous country. In the third place, all the decision-making power as for the future of the whole humanity, which falls in the United States of America today, is the result of the good historic measures which the aforementioned country had to take since the abolition of the slavery until the election of Barack Obama Chair of the United States of America. In the fourth place, the free access to the medical and pharmaceutical care for the Americans of the third age established by the Obama's Administration, has to become the starting up of the application of the "Law of Zero Profit" as for the American society which became fortunately the initiator of a new universal Order desired by the human race. In other hands, and in the fifth place, all the measures working towards the institution of a permanent and perpetual free health care for all citizens and assimilated-citizens honor the United States of America as a State-Nation blessed by God. In the sixth place, all

the countries, which opened the way to this happy state of affairs for the humanity, also receive the respect of the whole humanity. In the seventh place, the fate characterizing the countries where the inhabitants have to fight to get the necessary money for the most rudimentary medical care is a matter, which I condemn of curse. In the eighth place, it remains consequently normal that the set of political decisions ordering the gradual and sound institutionalization of the free health care for all citizens and assimilated-citizens, receives the approval of God who declares the aforementioned principle of the free medical and pharmaceutical care in use in a given society, a high fact of the human civilization.

Secondly, let us take the institutionalization little by little of the perpetual unemployment insurance. Let us consider the human poverty. Let us admit that the human poverty is given as the refusal of the human society to get for everyone the minimum living wage which will allow him/her to live normally, even if the aforementioned person living permanently in the aforementioned society, is unemployed either underemployed, has never had the opportunity to work during his/her sold existence, or is disabled person temporarily or definitively, in a acquired or hereditary way. Let us admit that the economic law governing any current human society, and which wants the profit to be the motive for investment or for the work of the entrepreneur, orders exactly the aforementioned human poverty [in the sense that the creation of a fund of perpetual unemployment benefit for every individual living permanently in the aforementioned society, stays a measure cancelling the economic profit and freeing purely and simply the economic interest

which pays the borrowed money] in one hand and others hands, let us consider a highly qualified, but put out of work, Worker for soon two years, and always incapable to find a job. Let us admit that the aforementioned American worker half handicapped because of his last employment where he had the evil spell to be bumped, tries in vain to find a work suited to his/her new physical condition, while taking lessons to the College to retrain. Let us admit that having exhausted his/her unemployment allowances after one year, the aforementioned worker, which finds himself/herself in inhuman living conditions, could no longer pay his/her rent and support himself/herself. Let us admit that would have the society to which belongs the aforementioned worker and his/her family, just had to have established the perpetual unemployment allowance, so that this one just has to be saved as well as his/her family, to note that the society absolutely needs its citizens for its economy and its future economic expansion. It results from these the following argument: In the first place, it is of common sense that the immediate creation of a fund of perpetual unemployment wage that must overturn a minimum of financial resources to every person living permanently in the society, and intended to eradicate absolutely poverty in the society right here in the United States of America, is an economic measure to be taken. In the second place, the global state economy is maintained in balance and continuing expansion because of the preservation in balance and continuing expansion of the national production of the necessary and sufficient goods and services. In the third place, the association global national Production and global national Demand of the economic goods

and services necessary, useful and pleasant to the society comes purely and simply under the fact that the produced national economic goods and services must be consumed so that new ones will be produced, and at risk of seeing them damaged and wasted. And the only ones of the citizens endowed with a real purchasing power, can ask for them, buy them and consume them. In the fourth place, the preservation of the elementary purchasing power of the worker facing the global national production of economic goods and services is absolutely assured by the institution of the Fund of perpetual unemployment allowance. In the fifth place, the principle of the perpetual unemployment allowances is given as the principles of the Sovereignty of the people, which is King in a perfectly democratic society. In the sixth place, the fact of the perpetual unemployment allowances is understood as a purely economic necessity. In the seventh place, the future practice of the application in the United States of America of the perpetual unemployment allowances is one of the most cherished wish of the author of the "Law of zero profit" for the future of the humanity.

Thirdly, let's take the gradual abolition of the work degrading the human being. Let us consider the work of the machine tool. Let us admit that the human being naturally endowed with free will or mood, can in no case be reduced to the machine tool and to it only. Let us admit that the work of a machine tool confided to a human being, degrades the latter to the rank of a machine tool and destroys him/her. Let us admit that the work of a worker forced to load and or unload a truck of several thousands of heavy packages or parcel, in an interval of time prefixed by the Entrepreneur, and

by the means of his/her hands, is given as the work of the machine tool, for example. Let us admit that the aforementioned work of a semi-skilled worker in the loading and unloading with bare hands of trucks of transport of parcel destroys necessarily this one who, at best, finds himself/herself with incurable and permanent pains at the level of his/her dorsal and other joints, making him/her for ever handicapped. Let us admit that to decide consciously on such a state of affairs consisting in establishing as one normal the work of the machine tool confided to a human being so strong he/she is, is purely and simply an act of crime against the humanity. It results form these the reasoning which follows: In the first place, the Civilization of the machine tool, hear by the industrialization and mechanization of the society, reaches its peak with the complete coverage of the work destroying the human being by the robot or the machine tool. Secondly, the aforementioned abolition of the destructive work of the worker in the production of the economic goods and services is ordered well and truly by the technological innovations, which remain a considerable asset for the human race.

CHAPTER 8: Conclusion

Now, let's examine more closely the principle of the abolition of the work damaging (degrading) the human being. Because the purpose of the "Law of Zero Profit" is identified by the principle of the maximum individual and social welfare, let us examine at the moment, the aforementioned principle. Let us consider the primitive capitalist system, which wants that the maximum profit be realized on the back of the workers as purpose and motive for the investment of the capital. Let us admit that the "Law of Zero Profit" which poses the "maximum individual and social well-being of the worker" as the purpose of the political power within the society, is exactly the opposite of the social action of the businessman/ businesswoman or the entrepreneur. Let us admit that the economic system created by the "Law of Zero Profit" which finds natural and suitable the economic Liberalism or Capitalism, conceives the political Action as the regulator waited by the workers employed or unemployed of the society.
Let us admit that the fiscal system created by the "Law of Zero Profit" which summarizes the complete application of the aforementioned law as for a given country, becomes finally the tool dreamed to beg forever the violence and the organized poverty of the society, so that the civil Peace and the maximum individual and social well-being are realized. It results from these the reasoning which follows: In the first place, the current American political system of which

the author of the "Law of Zero Profit" is proud, especially since the election of Barack Obama President of the United States of America, is positioned by the providence the one which intends to lead effectively the "train of the future of the whole humanity". Secondly, if the French self-handler political sensitivity could wake up to the "Law of Zero Profit" and take the reins of political power in France, the aforementioned country, could substitute the USA in the "realization of the lost Heaven" on Earth or the "Construction of the Building of the human absolute Happiness". Thirdly, by means of the United Nations Organization, even western Countries or Countries acquired in the principles of the rule of law and the Democracy, Togo, the native country of the author of the "Law of Zero Profit" could realize the third chance to see gradually restored the "eternal Africa" and the "Heaven on Earth"

POSTECRIPT: The Complete Removal of the Paradox of the Poverty within the Abundance

Let's look at the overall situation of the homeless in America.

Let's establish the functional identity of the representation of the said situation of the homeless as the national solidarity effort necessary to reverse the said paradox of the poverty within the abundance.

Let us assume that the effort of American national solidarity necessary to totally eliminate the paradox of poverty within the abundance generated by the high state of industrialization of the United States of America, is equivalent to a tax to be applied to any product purchased on the national territory of the United States, called the National Solidarity Tax (NST), which must absolutely finance the Perpetual Unemployment Benefit Fund, the compulsory free health insurance for all American citizens and assimilated, and the progressive elimination of human robot work.

This leads to the following reasoning:

First, the National Solidarity Tax (NST) is a proposal for a constitutional law from the author of this Treaty in Arts and Sciences.

Second, the proposed constitutional law will be part of

an election platform of an American political party that deems it to be a saving force for the American nation and the world.

Third, once the national solidarity tax voted by the American people is effective, its full application automatically guarantees the emergence of the "earthly paradise" so dreamed by every human being for every human being.

Works Cited

In English

Friedman, Milton. *Capitalism and Freedom*. University of Chicago Press. November 2002. First published 1962.

Keynes, Maynard John *The General Theory of Employment, Interest and Money* Palgrave Macmillan February 1936

Marx, Karl. *Capital: A Contribution to the Critique of Political Economy*. Hamburg: Meissner, Von Otto 1867

Malthus, Thomas Robert, *An Essay on the Principles of Population* London, L. Johnson. 1798

Mill, John Stuart. *Principles of Political Economy*. John W. Parker 1848

Mill, John Stuart. *Essays on Economics and Society* University of Toronto Press; London: Routledge and Kegan Paul. April 1967

Ricardo, David *The Principles of Political Economy and Taxation* London, JohnMurray April 1817

Samuelson, Paul. *Foundations of Economic Analysis*. Harvard University Press. 1947

Say, Jean Baptiste. *Treaty of Political Economy.* (1803). Paris: Calmann-Levy Editor, 1972

Smith, Adam *an Inquiry into the Nature and Causes of the Wealth of Nations.* Strahan, William, Cadell, Thomas March 1776.

In French

Messavussu, Moe. *La Metamorphose* Les Editions Bleues – Amazon.com 2012

FIGURES

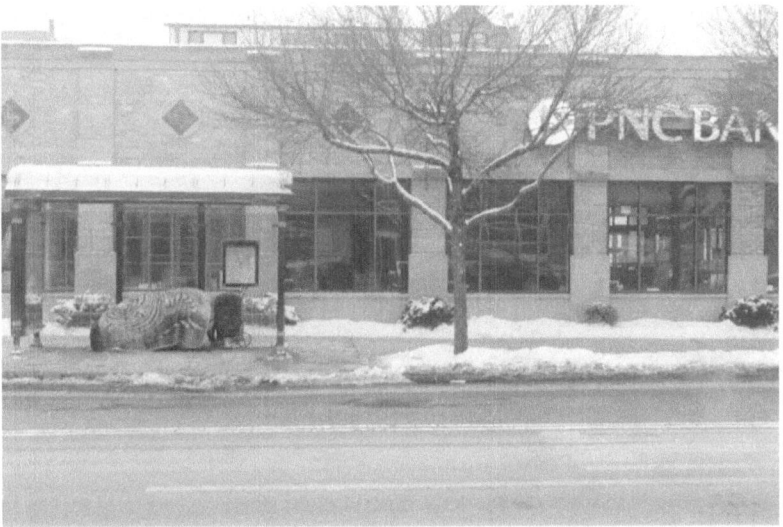

Figure 1. A sleeping homeless on the bus stop bench in front of PNC Bank, shot by Moe Messavussu, December 2018

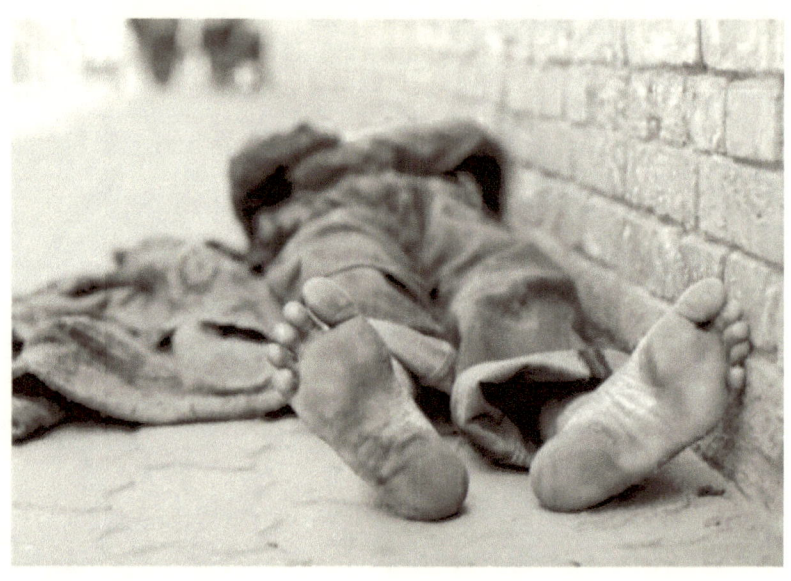

Figure 2. A homeless sleeping on the edge of a street. Unknown photographer

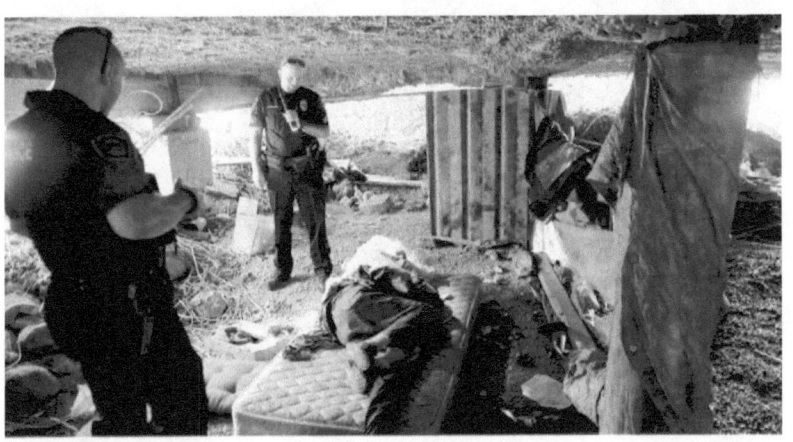

Figure 3. A sleeping homeless under a bridge. Unknown photographer

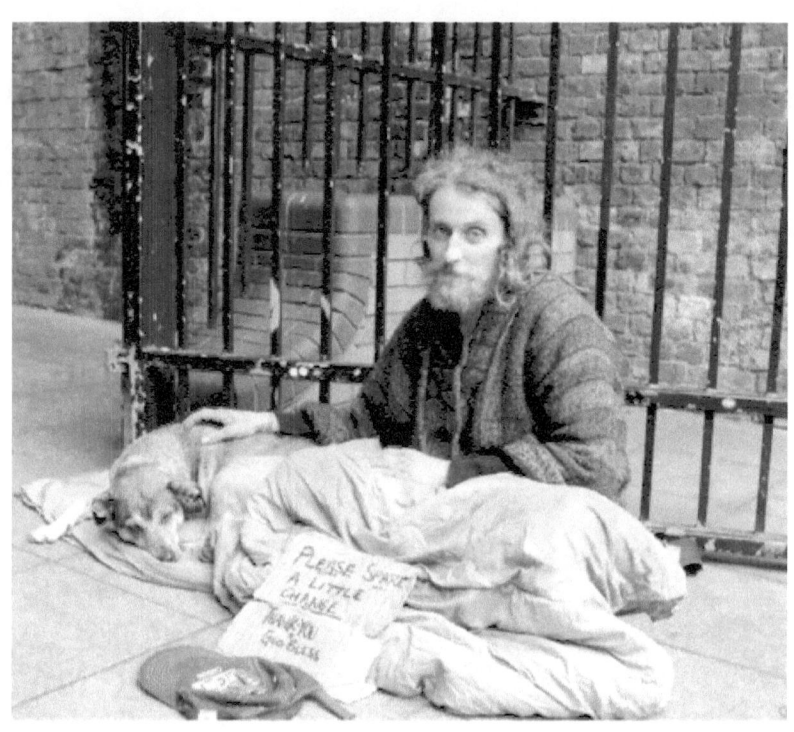

Figure 4. A homeless begging for help in the street's pedestrian crossing. Unknown photographer

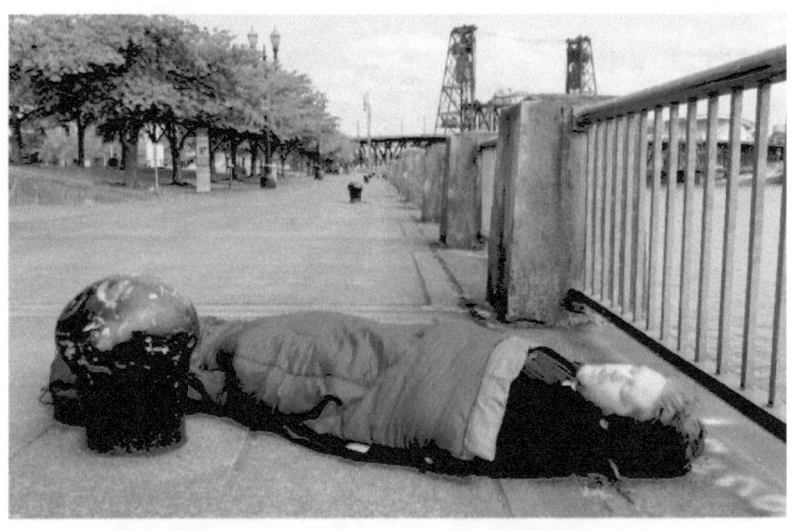

Figure 5. A young homeless sleeping on the edge of a pedestrian walkway. Unknown photographer

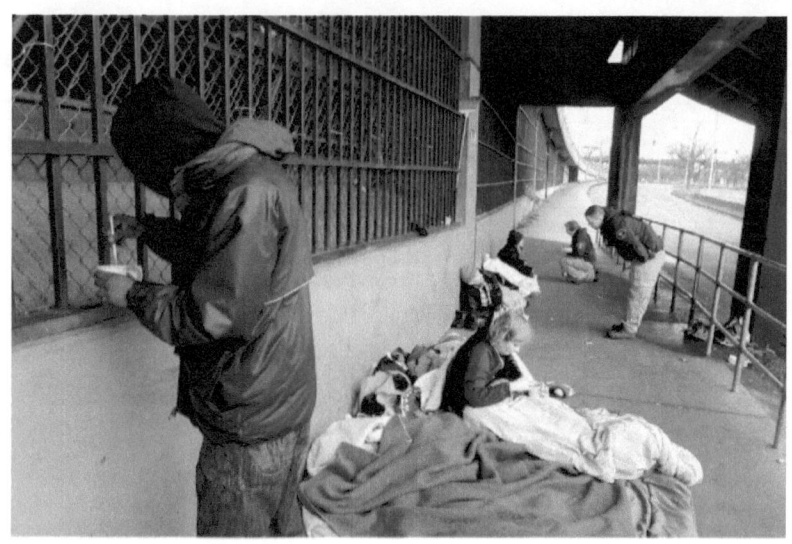

Figure 6. Homeless persons occupying a side of a pedestrian walkway under a bridge. Unknown photographer

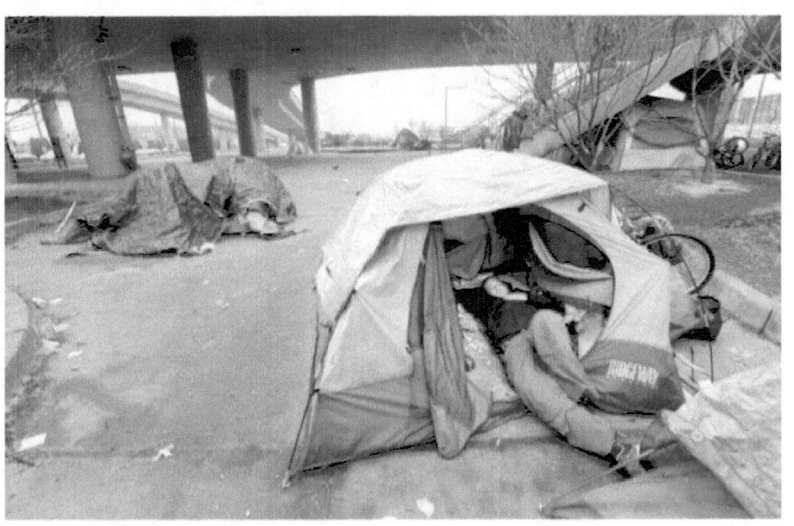

Figure 7. Homeless persons occupying a vacant space under a bridge. Unknown photographer

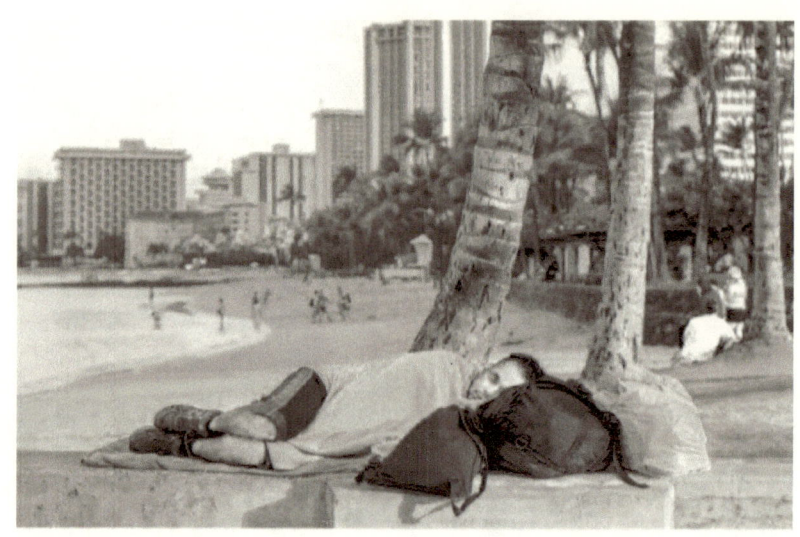

Figure 8. A young homeless sleeping under coconut trees on the edge of a beach. Unknown photographer

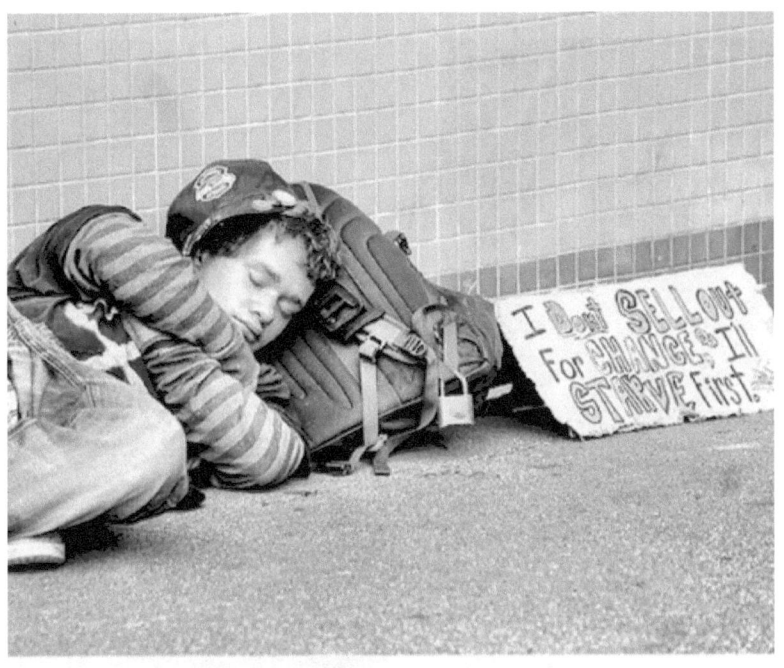

Figure 9. A young homeless sleeping on the edge of a pedestrian walkway. Unknown photographer

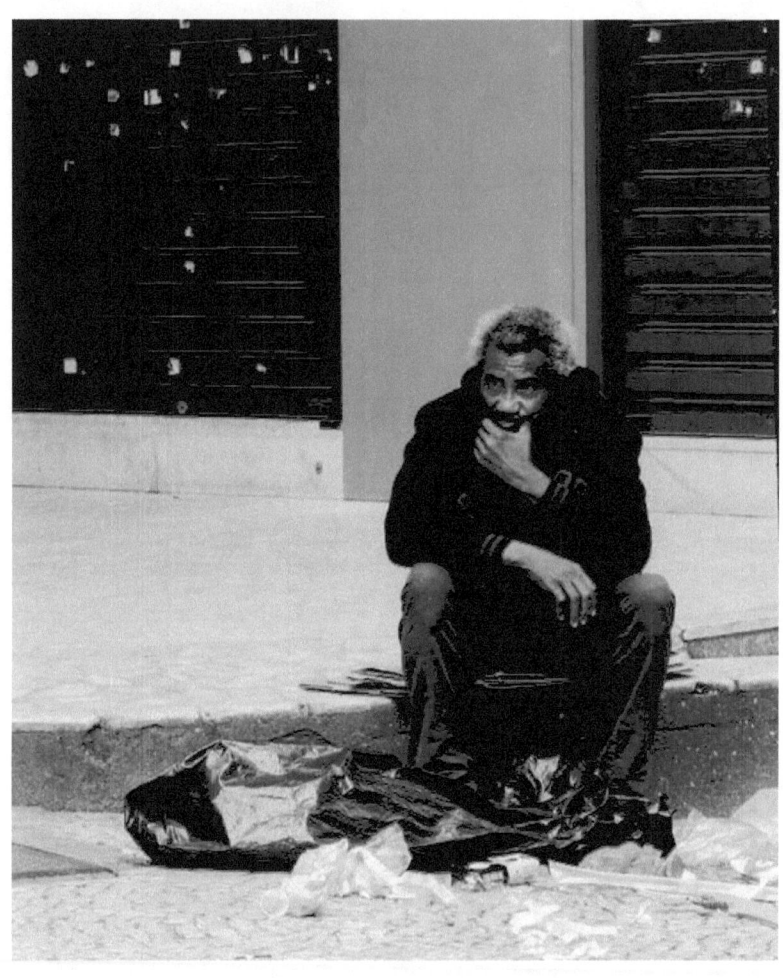

Figure 10. A homeless man sitting on the edge of a pedestrian walkway. Unknown photographer

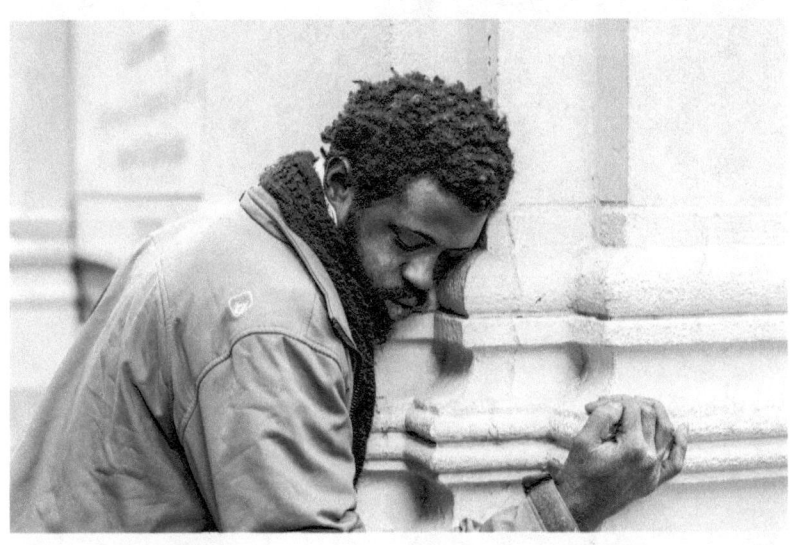

Figure 11. A homeless man sleeping in a pedestrian walkway. Unknown photographer

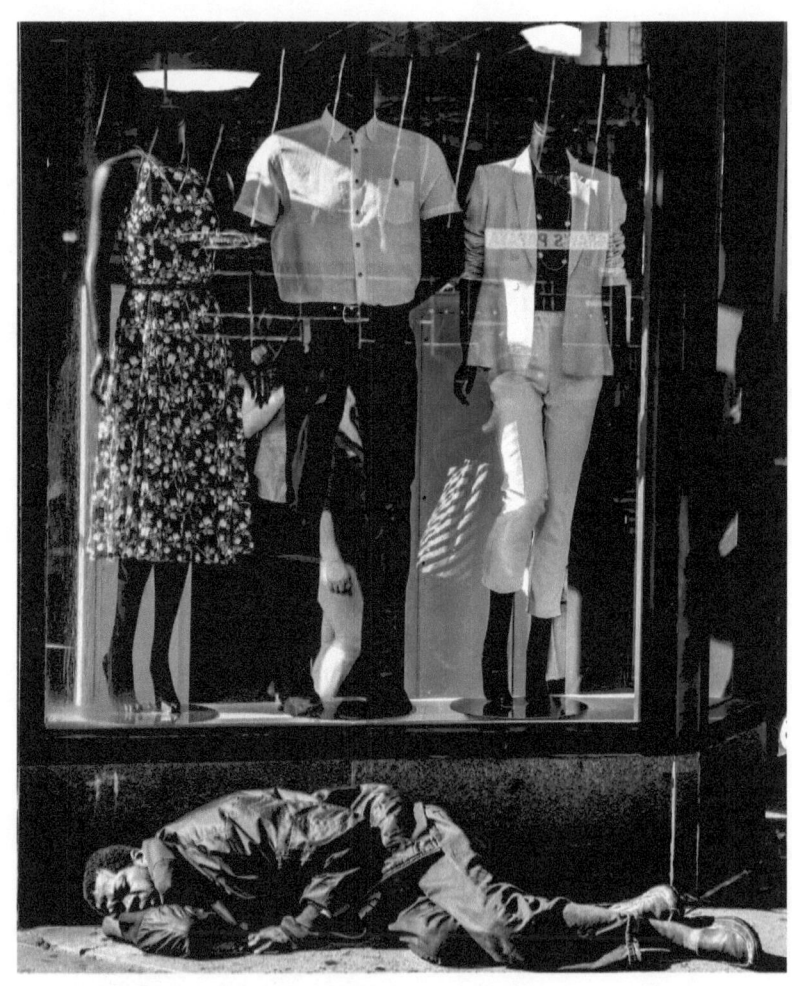
Figure 12. A homeless man sleeping on the edge of a pedestrian walkway. Unknown photographer

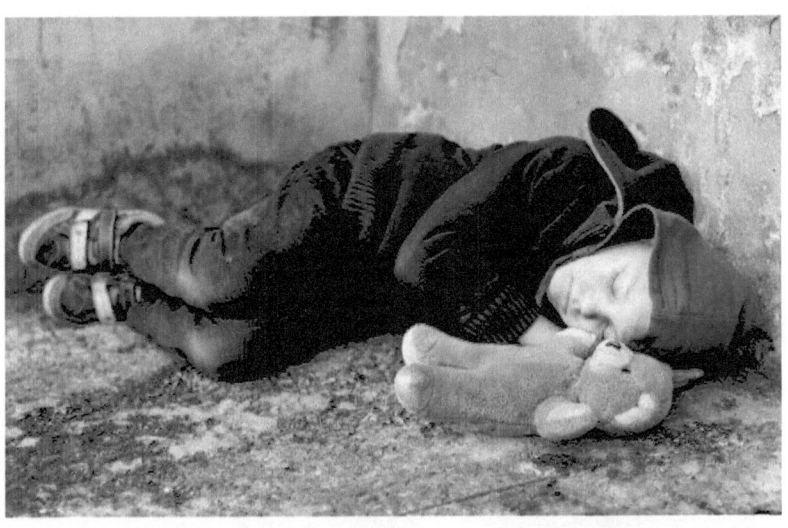

Figure 13. A homeless family staying on the edge of a pedestrian walkway. Unknown photographer

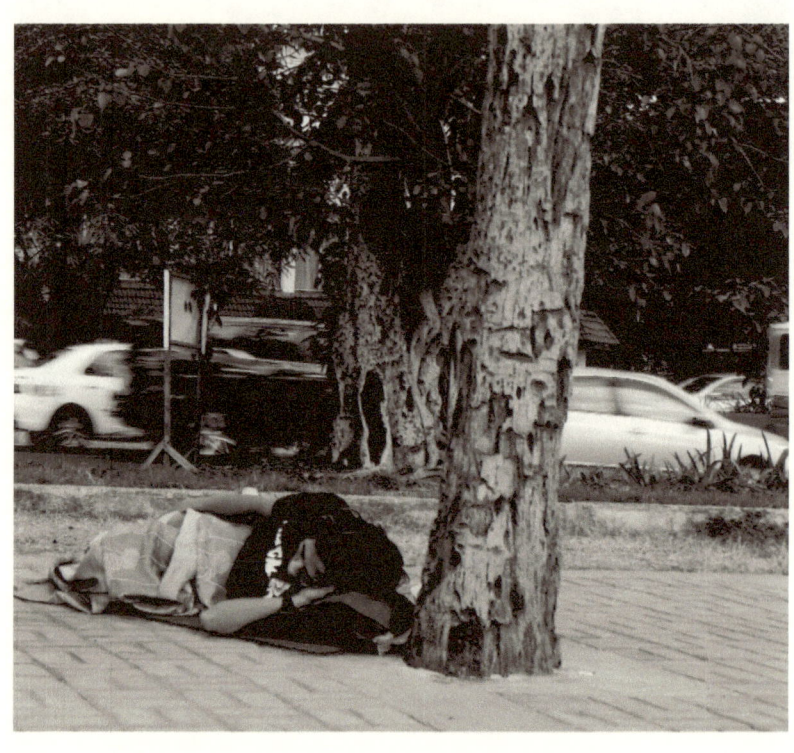

Figure 14. A young homeless sleeping on the edge of a pedestrian walkway. Unknown photographer

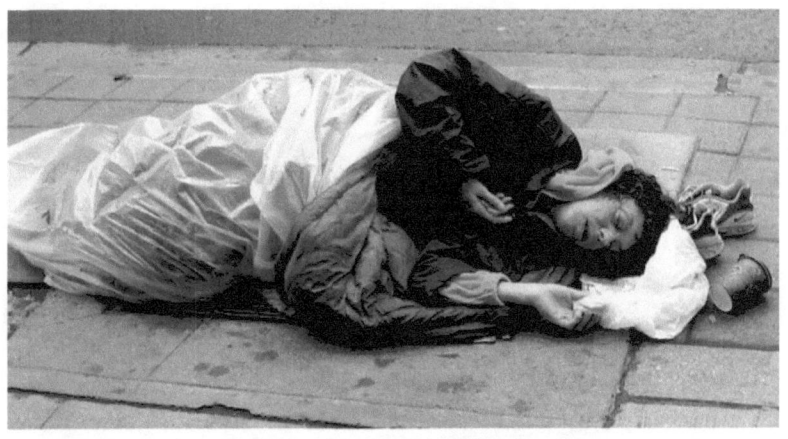

Figure 15. A homeless man sleeping on the edge of a pedestrian walkway. Unknown photographer

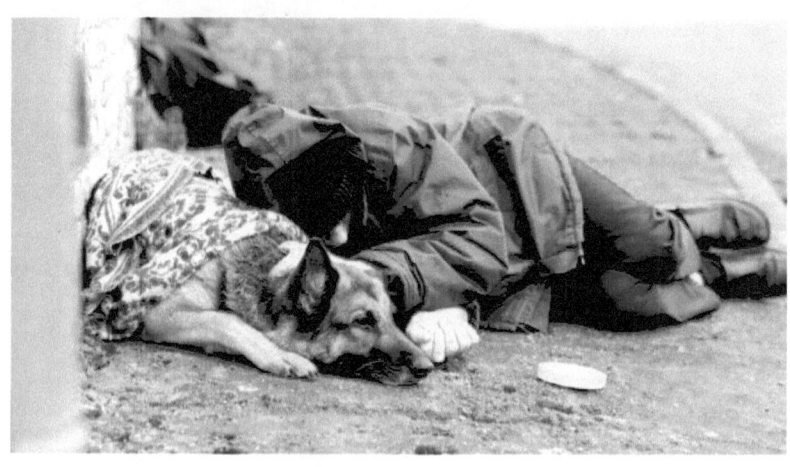

Figure 16. A homeless person with his dog sleeping on the edge of a pedestrian walkway. Unknown photographer

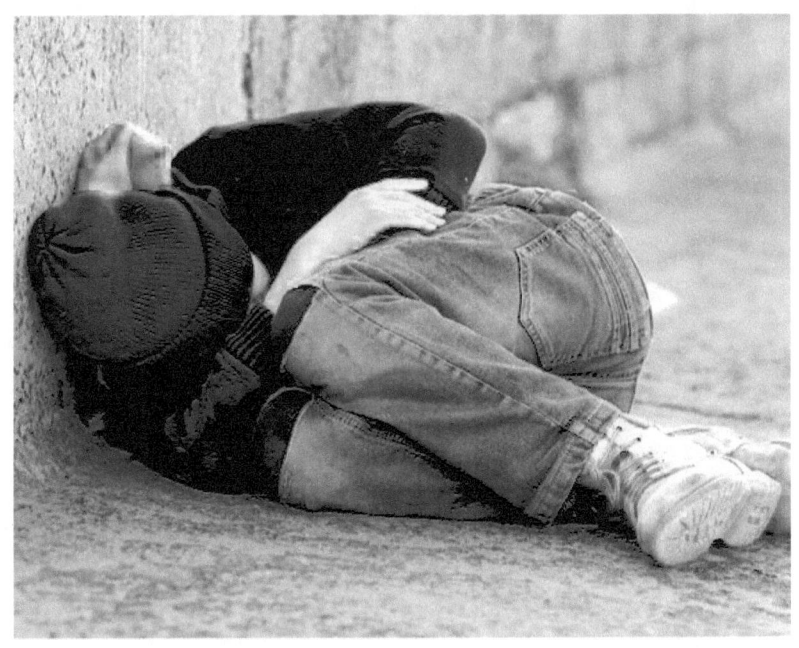

Figure 17. A young homeless sleeping on the edge of
a pedestrian walkway. Unknown photographer

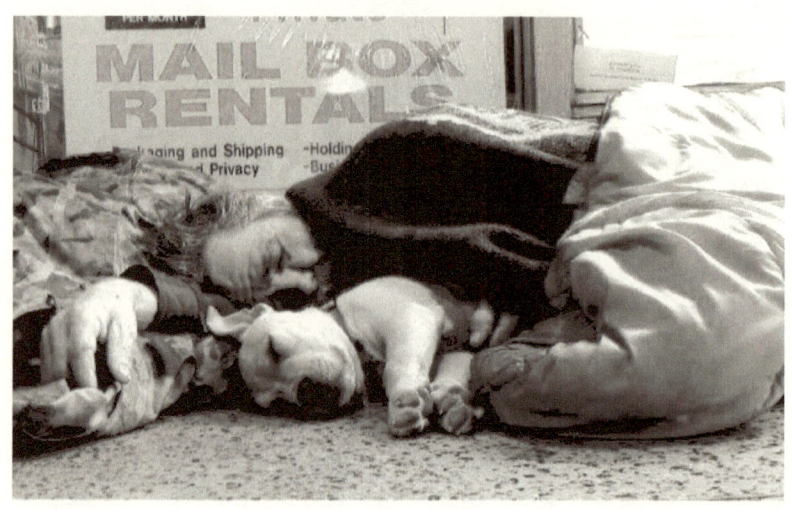

Figure 18. A homeless man with his dog sleeping on the edge of a pedestrian walkway. Unknown photographer

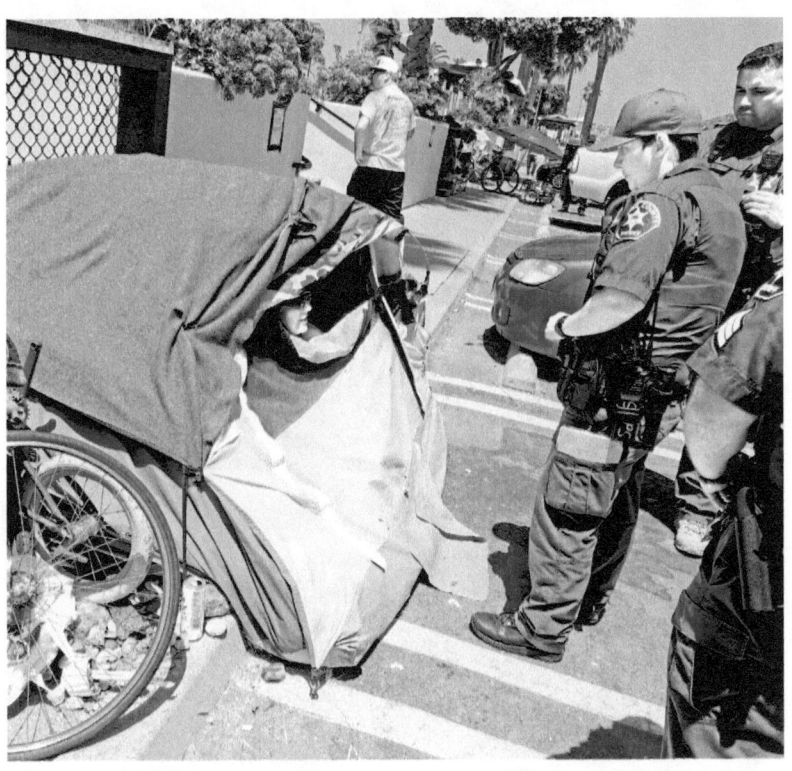

Figure 19. A homeless woman occupying the edge of a pedestrian walkway. Unknown photographer

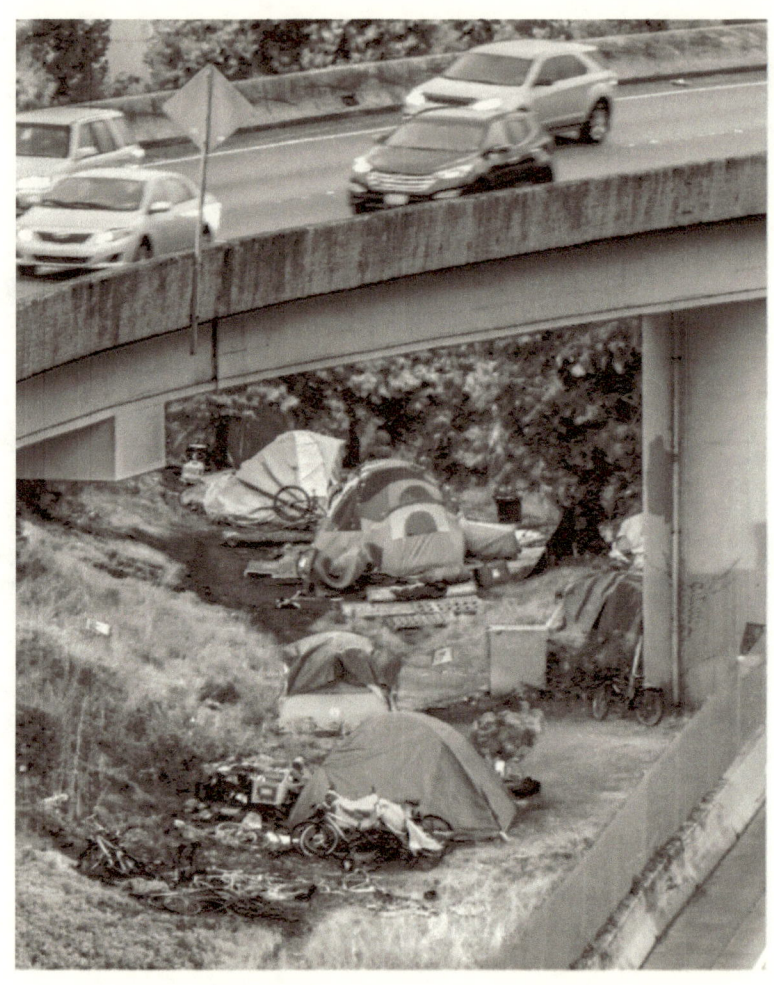

Figure 20. Homeless persons occupying a space under a bridge. Unknown photographer

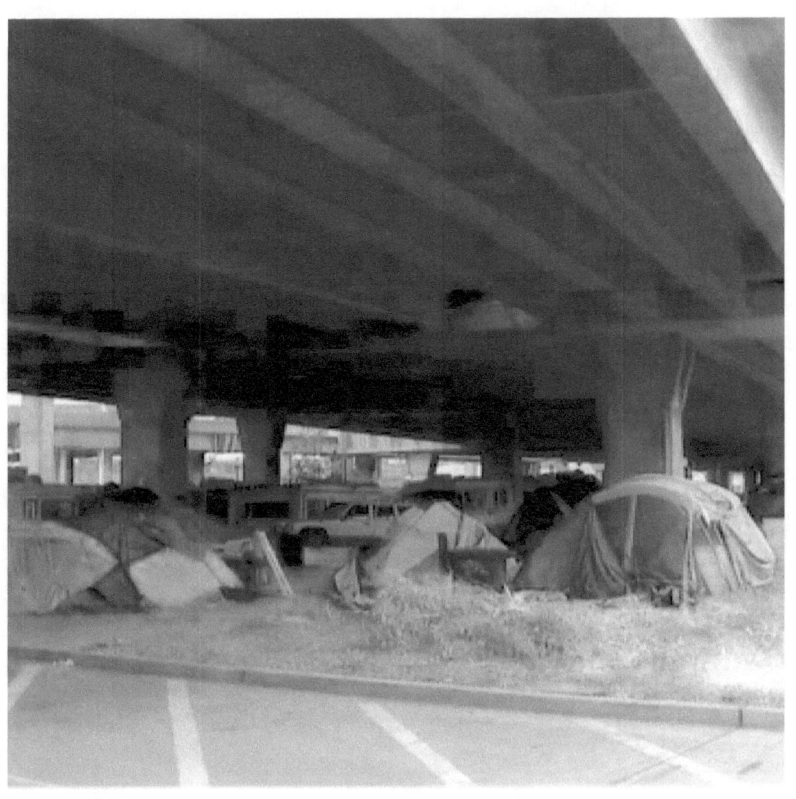

Figure 21. Homeless persons occupying a space under a bridge. Unknown photographer

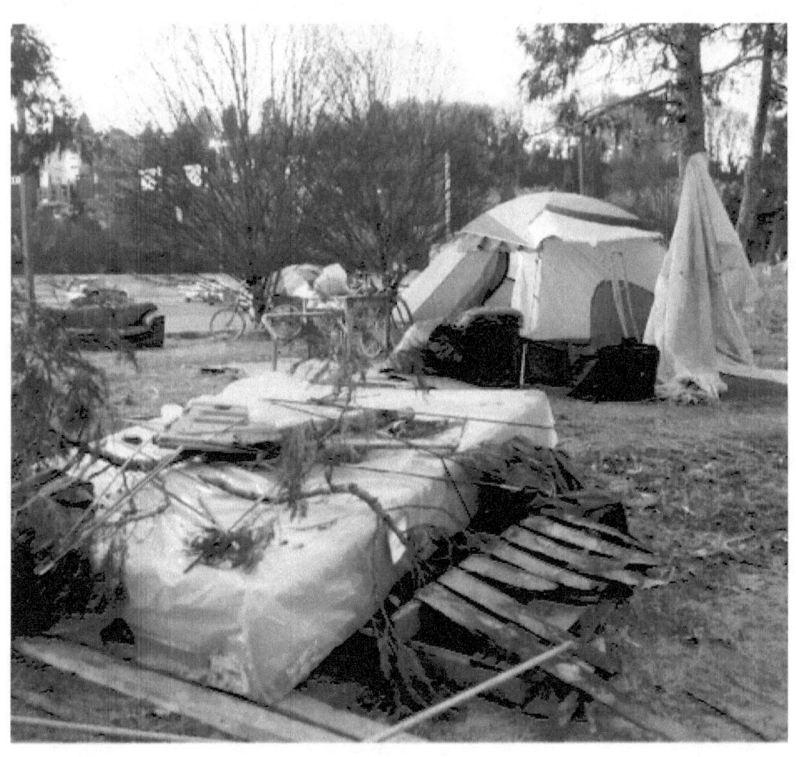

Figure 22. Homeless persons occupying a space aside of a highway. Unknown photographer

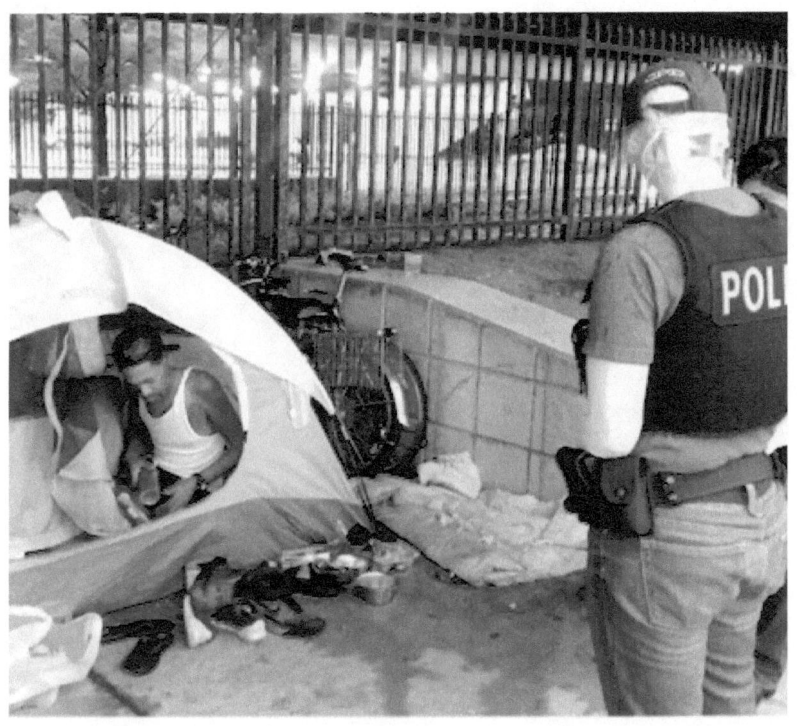

Figure 23. A home of a homeless. Unknown photographer

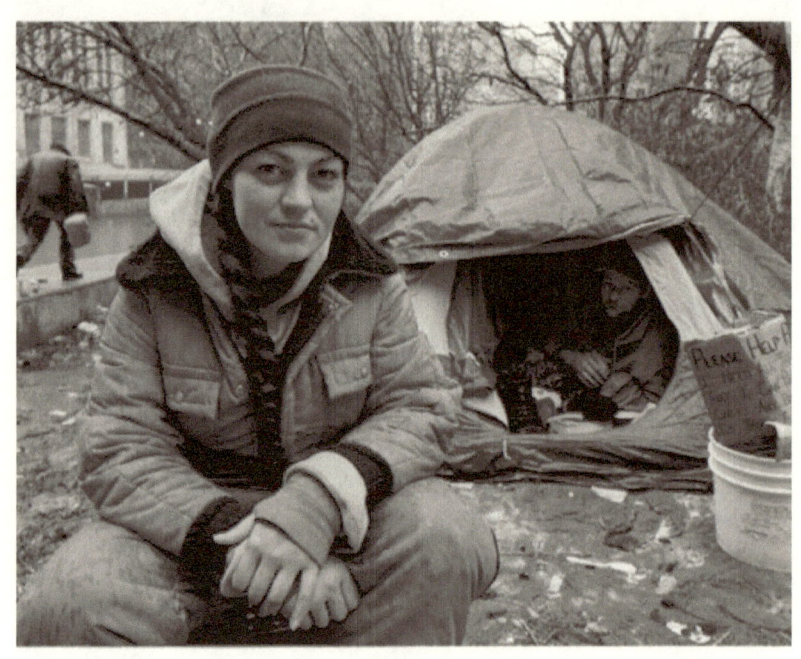

Figure 24. A home of a couple homeless.
Unknown photographer

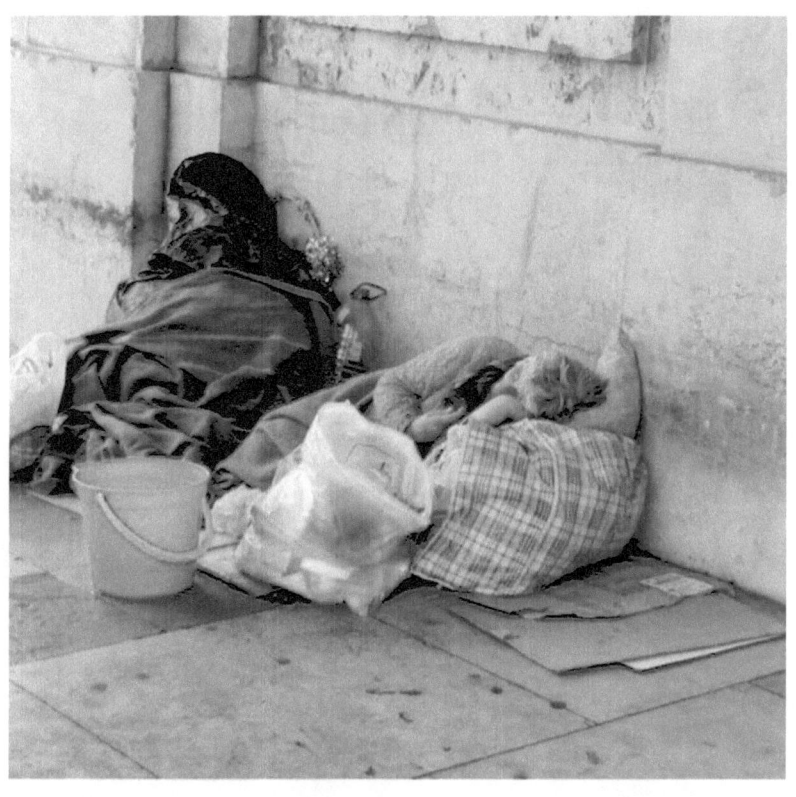

Figure 25. A homeless woman sleeping on the edge of a pedestrian walkway. Unknown photographer

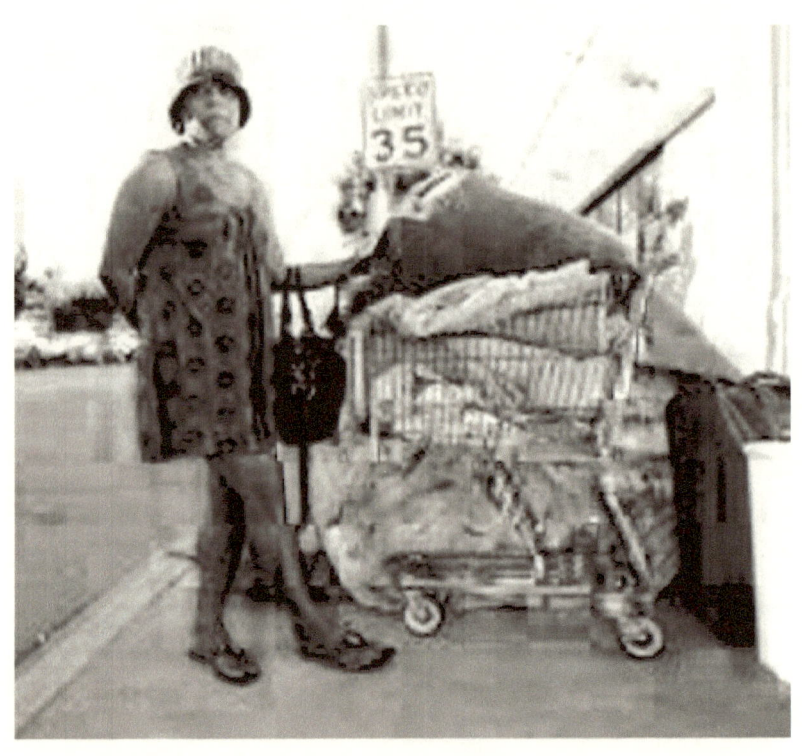

Figure 26. A homeless woman standing on the edge of a pedestrian walkway.
Unknown photographer

Figure 27. A homeless woman sleeping on the edge of a pedestrian walkway. Unknown photographer

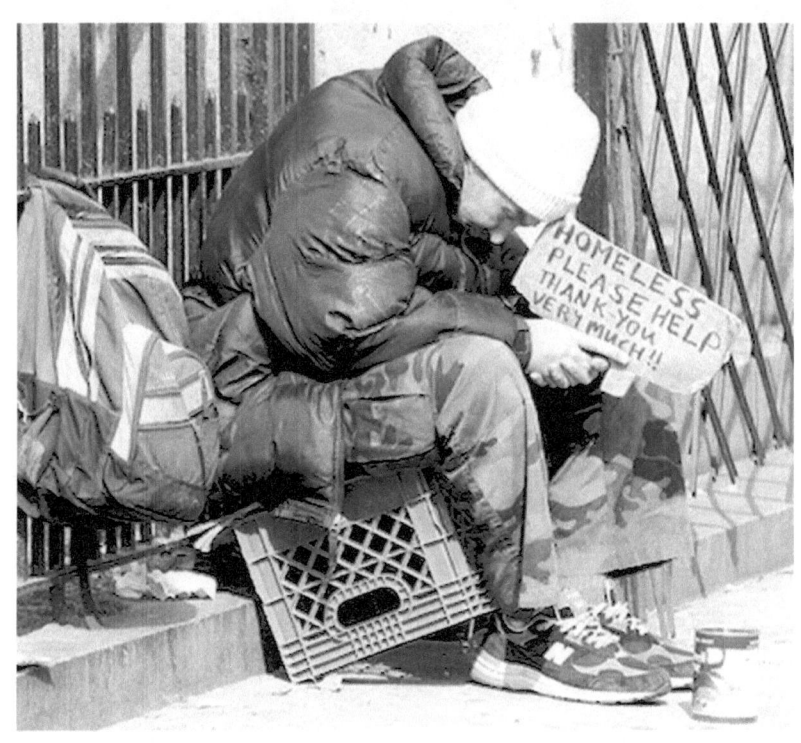

Figure 28. A homeless man sitting on the edge of a pedestrian walkway. Unknown photographer

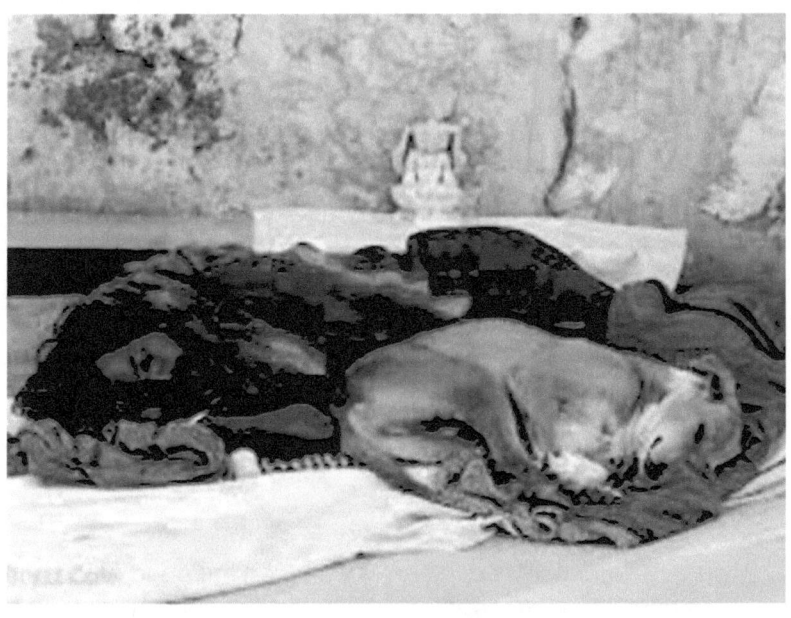

Figure 29. A homeless man with his dog sleeping on the edge of a pedestrianwalkway. Unknown photographer

Figure 30. Homeless persons sleeping on the edge of a pedestrian walkway. Unknown photographer

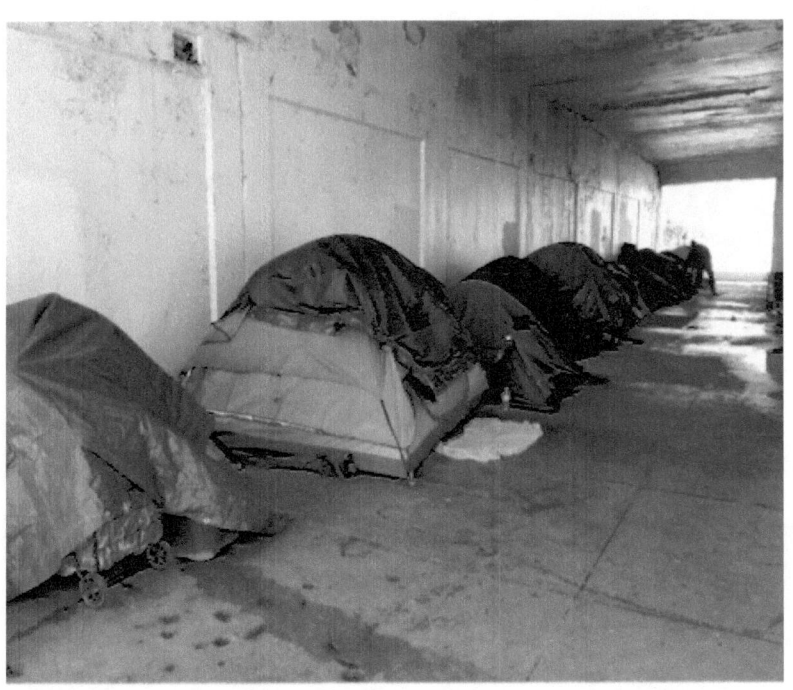

Figure 31. Homes of Homeless persons under a bridge.
Unknown photographer

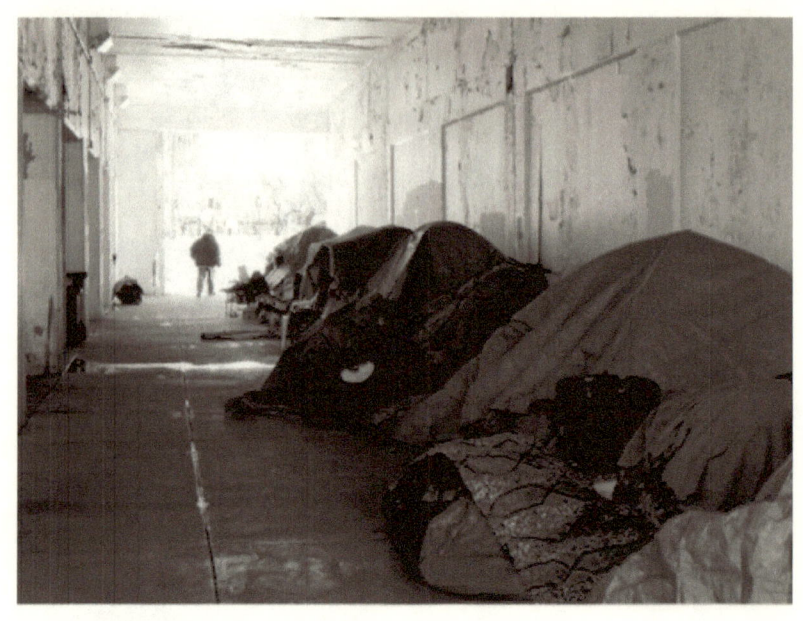

Figure 32. Homes of Homeless persons under a bridge.
Unknown photographer

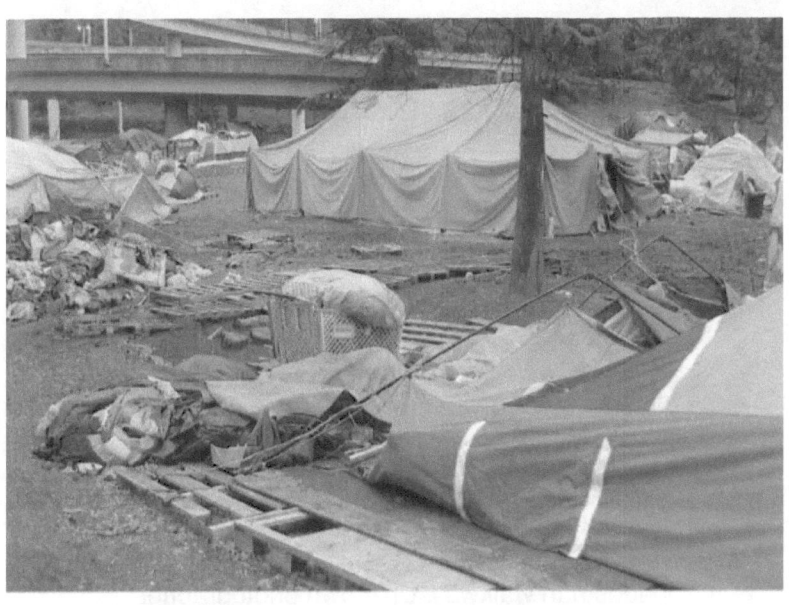

Figure 33. Homes of Homeless persons aside of a bridge.
Unknown photographer

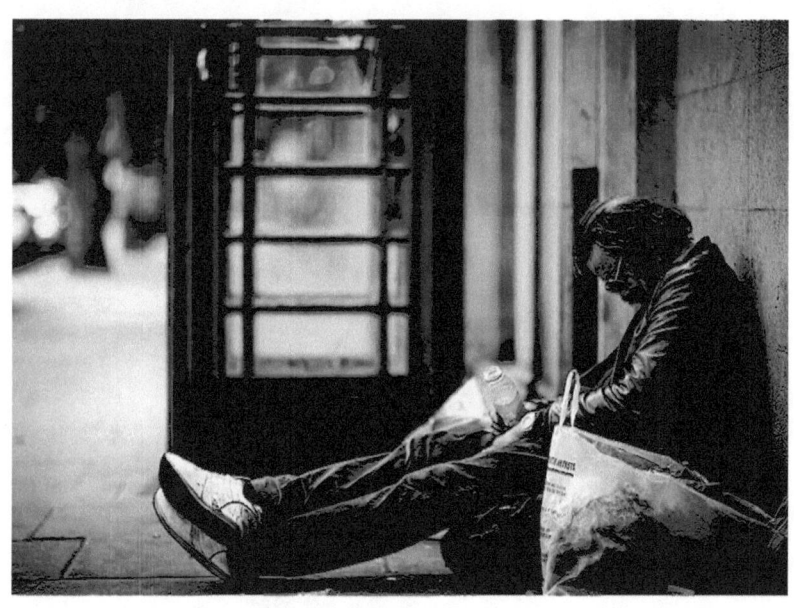

Figure 34. A homeless person sittinging on the edge of a pedestrian walkway. Unknown photographer

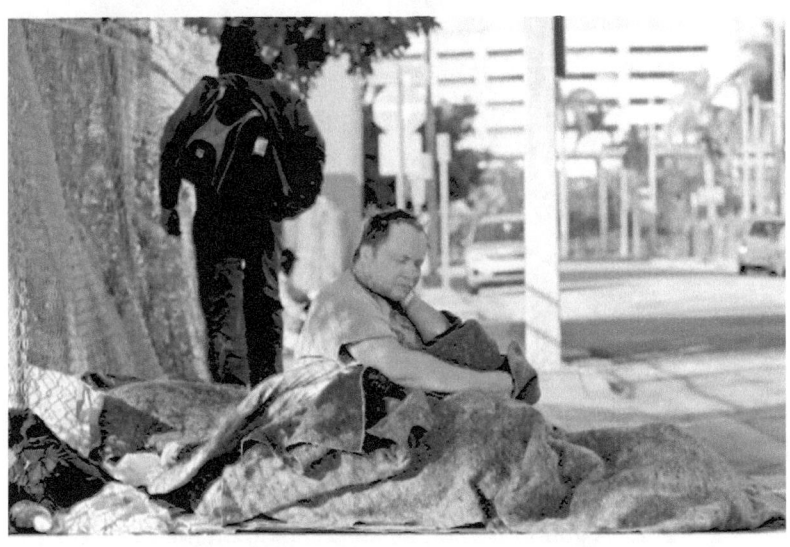

Figure 35. A homeless man sittinging on the edge of a pedestrian walkway. Unknown photographer

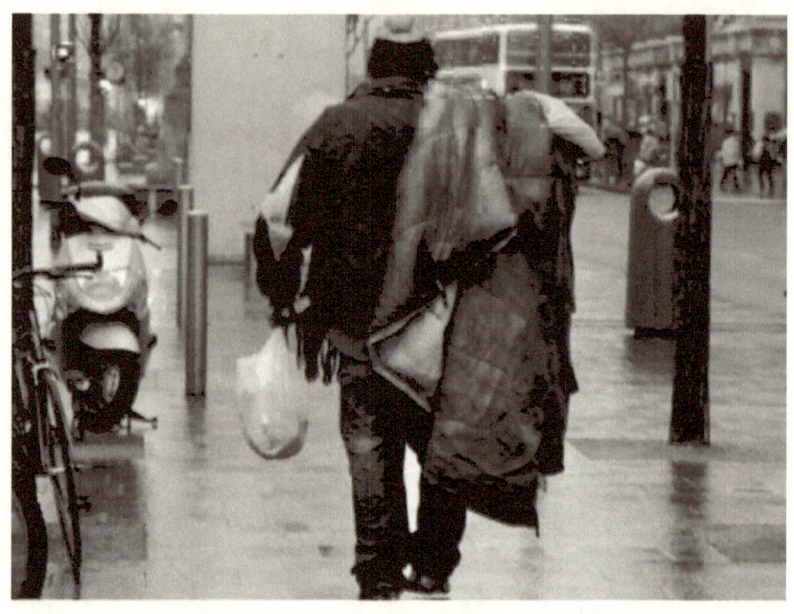

Figure 36. A young homeless steppinging on the edge of a pedestrian walkway. Unknown photographer

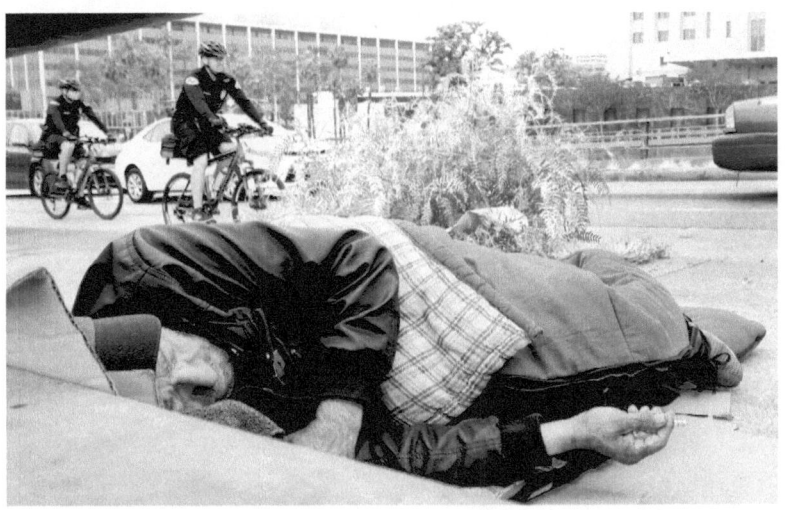

Figure 37. A homeless man sleeping on the edge of a pedestrian walkway. Unknown photographer

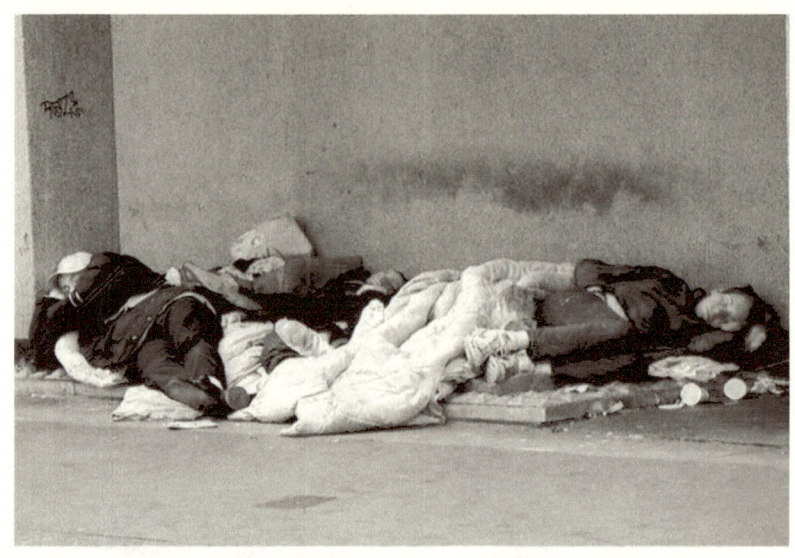

Figure 38. A couple of homeless persons sleeping on the edge of a pedestrian walkway. Unknown photographer

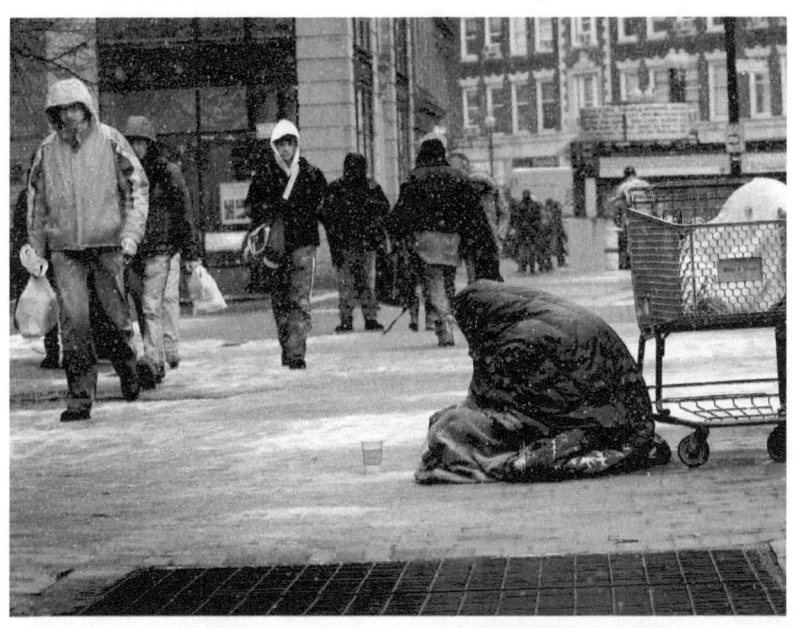

Figure 39. A young homeless sitting on the edge of a pedestrian walkway. Unknown photographer

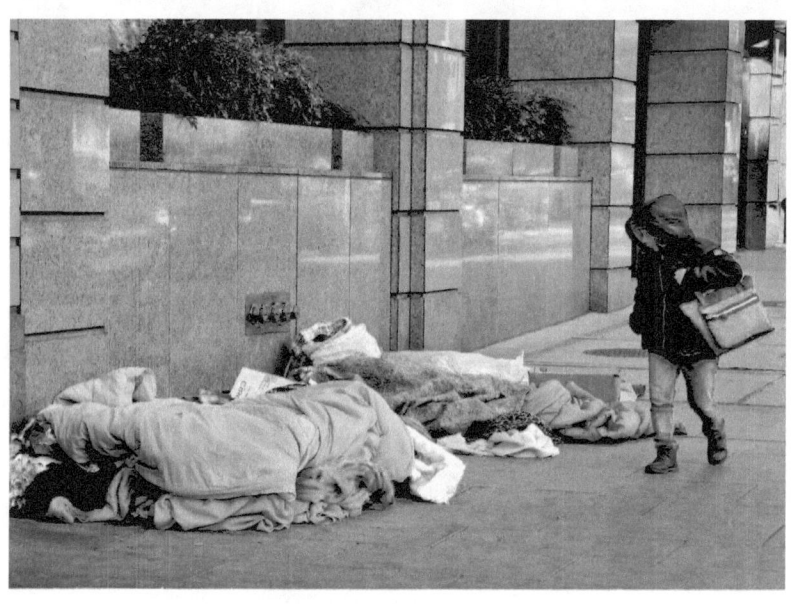

Figure 40. A couple of homelesses sleeping on the edge of a pedestrian walkway. Unknown photographer

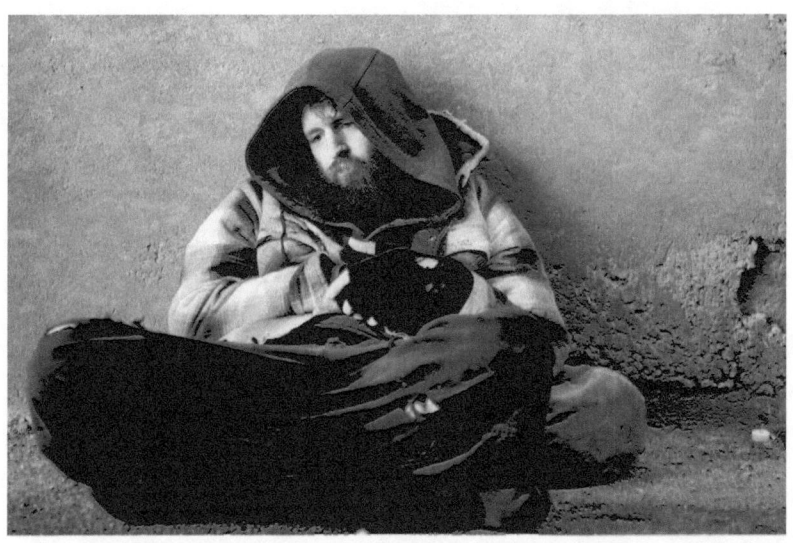
Figure 41. A young homeless resting on the edge of a pedestrian walkway. Unknown photographer

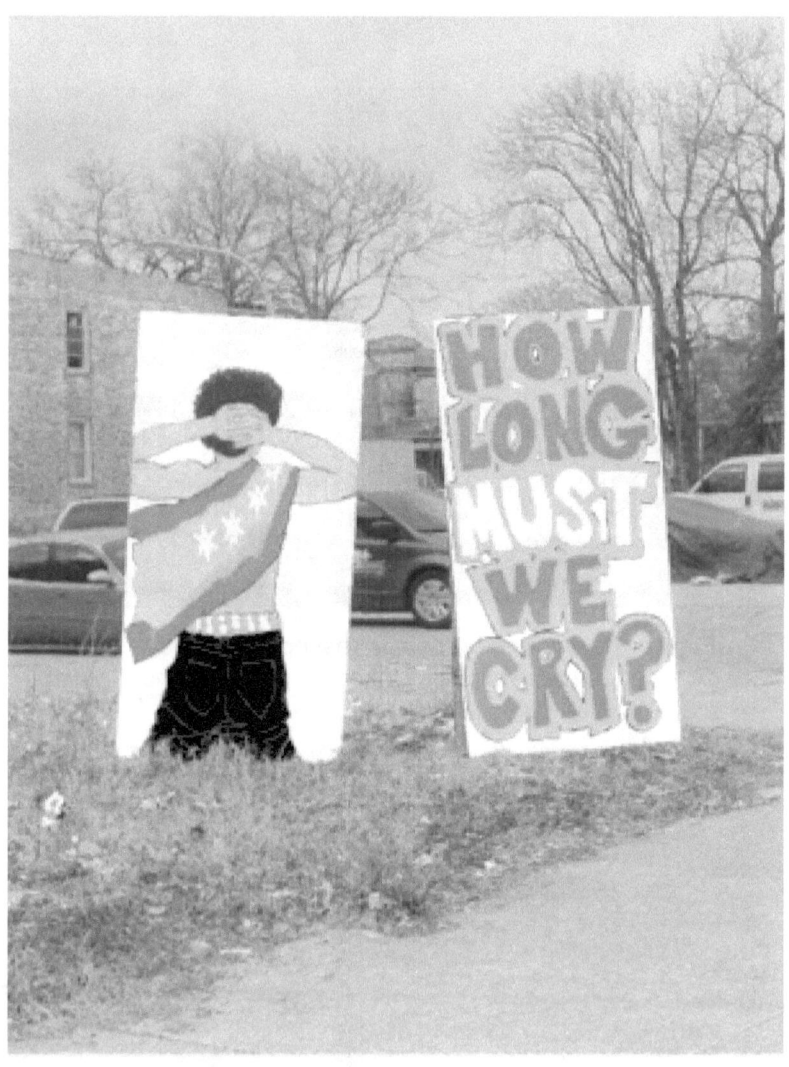

Figure 42. The despair of the poor. Shot by Moe Messavussu. November 2017

Utterly printed in August 2019 by
LES EDITIONS BLEUES
mmessavussu@gmail.com
moemessavussu@hotmail.com

Copyright registration: 3rd quarter 2019
Publisher's Number: 2-913-771

PRINTED IN THE UNITED STATES OF AMERICA

www.ingramcontent.com/pod-product-compliance
Lightning Source LLC
Chambersburg PA
CBHW022125170526
45157CB00004B/1765